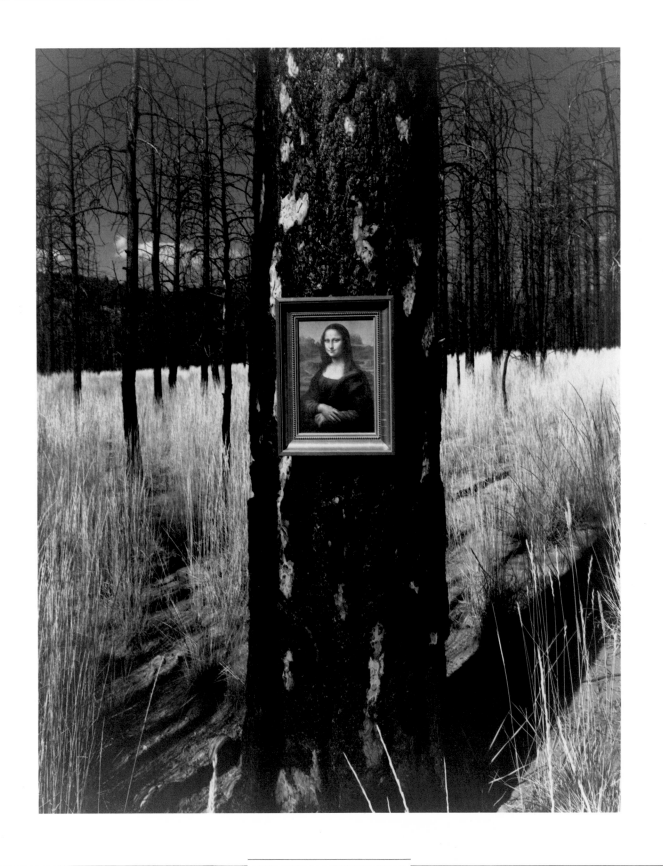

EUROPEAN INFLUENCE

PHOTOGRAPHS

Elliott McDowell

DAVID R. GODINE, PUBLISHER · BOSTON

First published in 1981 by
David R. Godine, Publisher
306 Dartmouth Street
Boston, Massachusetts 02116

LC 81-6604

Designed by Lance Hidy, Lancaster, N.H.
Printed by Gardner-Fulmer Lithograph,
Buena Park, California

Printed in the United States of America

Dedicated to my audience.

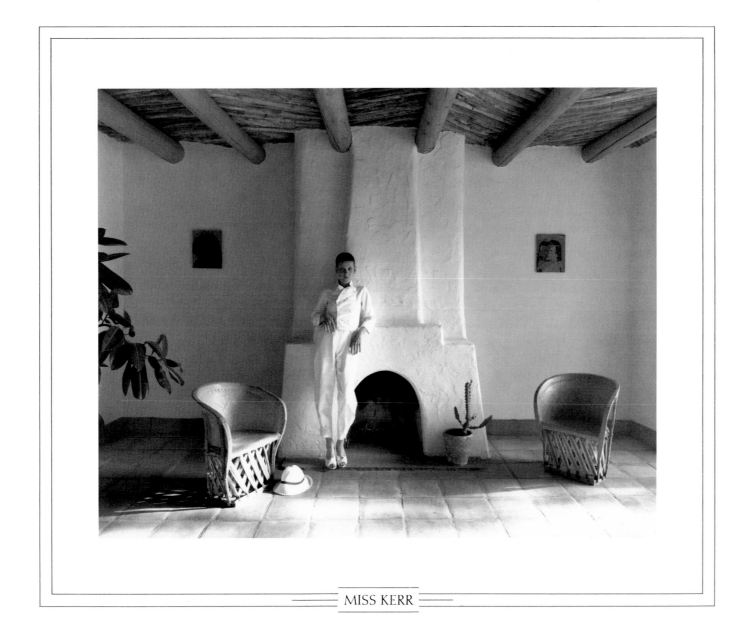

MISS KERR

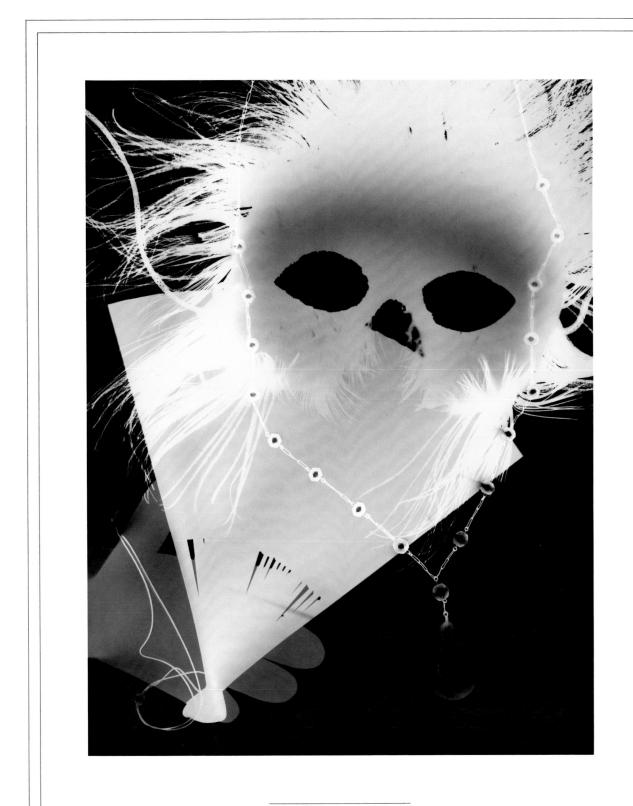

PHOTOGRAM NO. 6

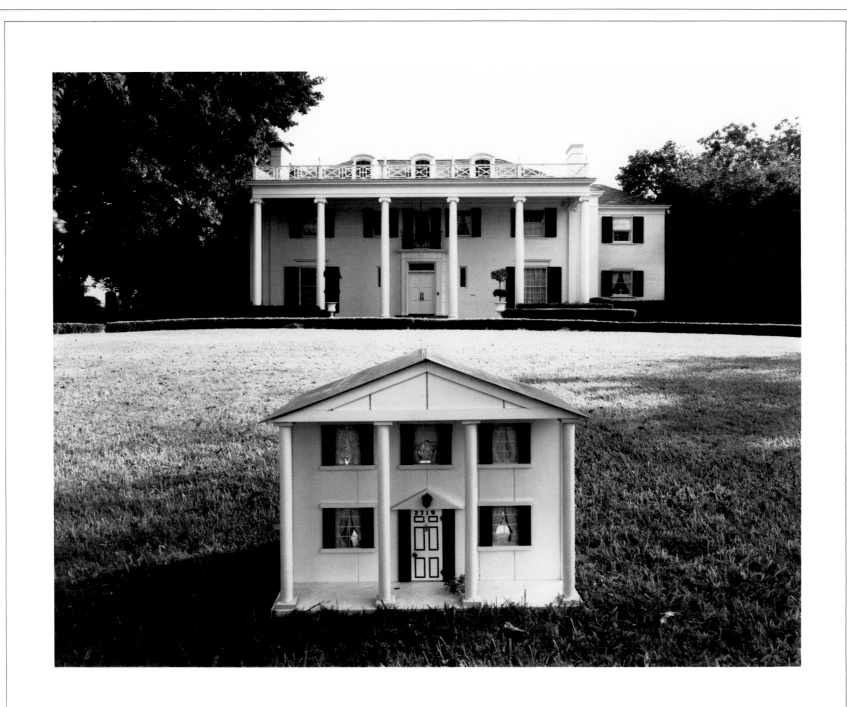

THE DOLL HOUSE

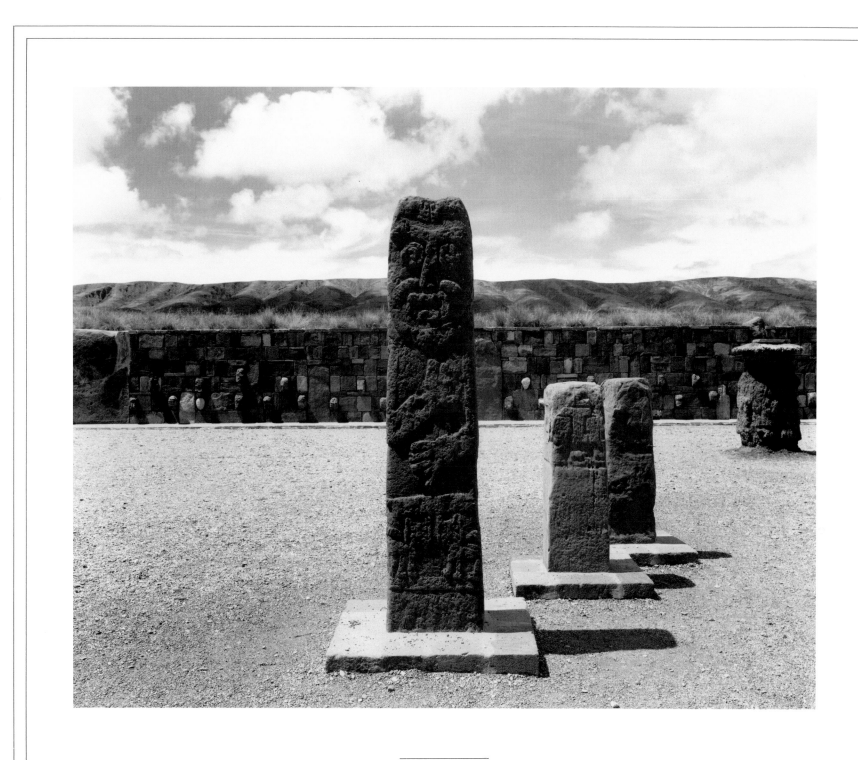

TIWANAKU

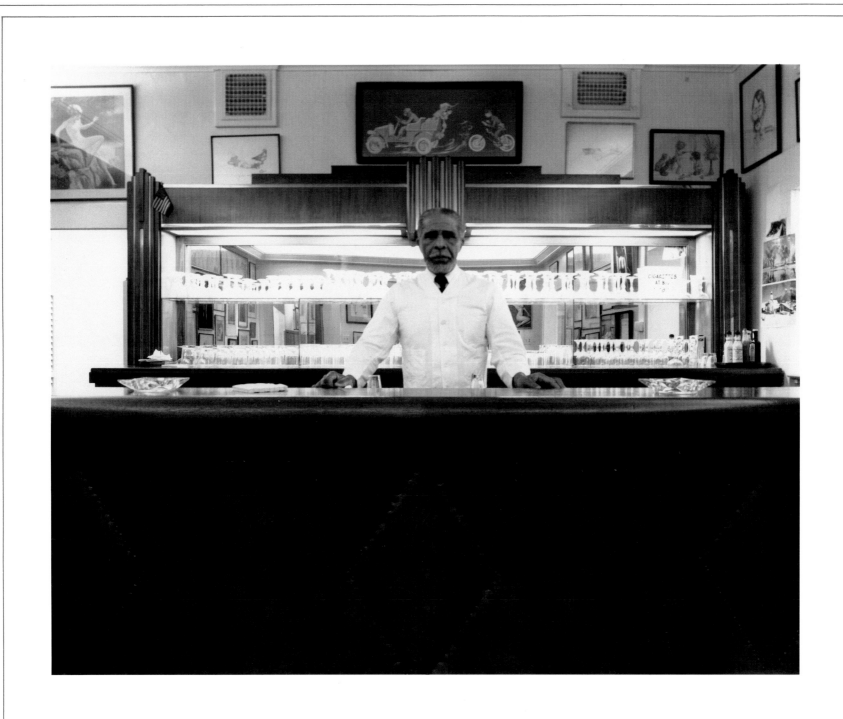

ALFRED, THE BENTON CLUB

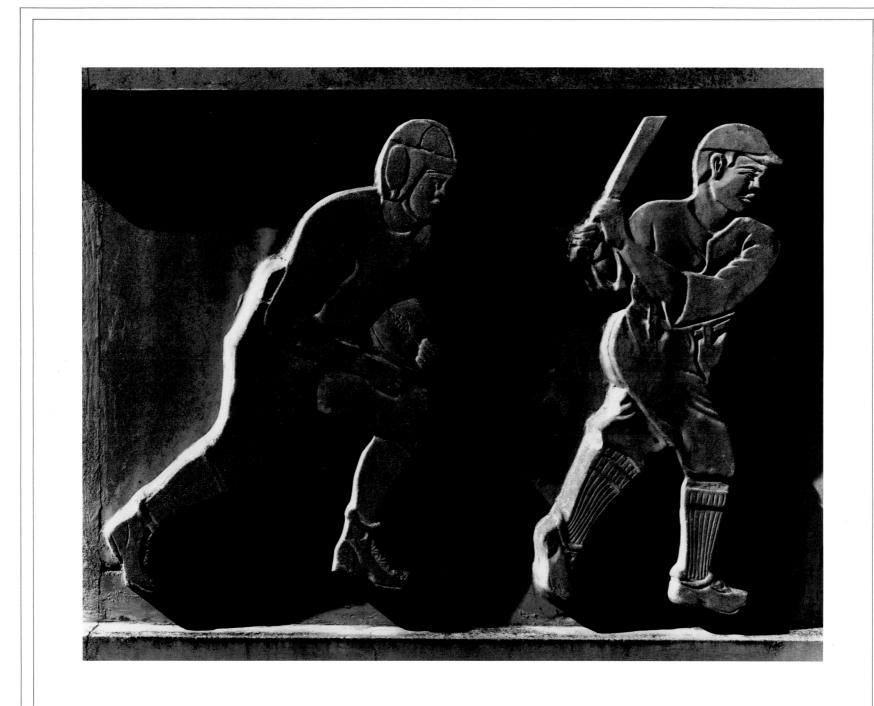

SPORTS FIGURES, COBB STADIUM

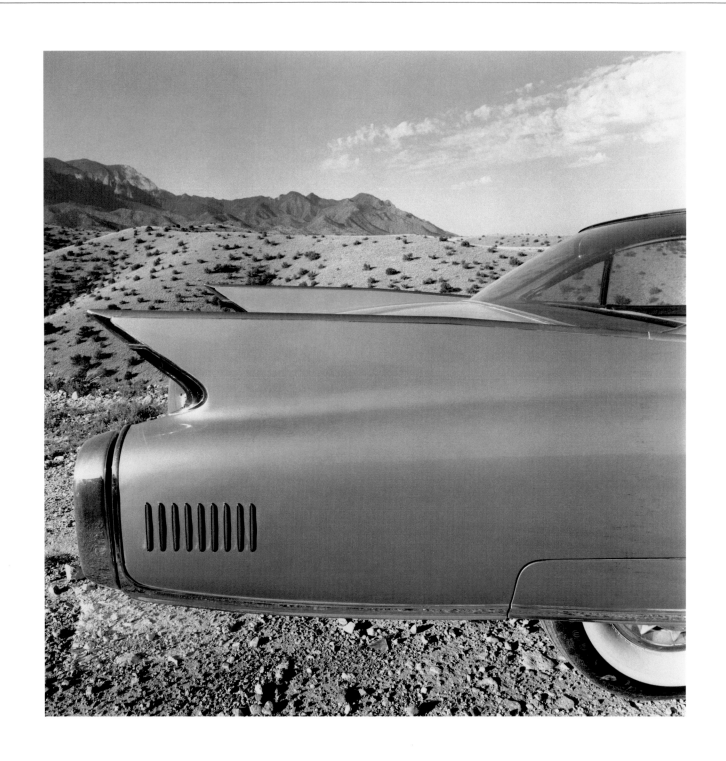

FLEETWOOD, NEW MEXICO

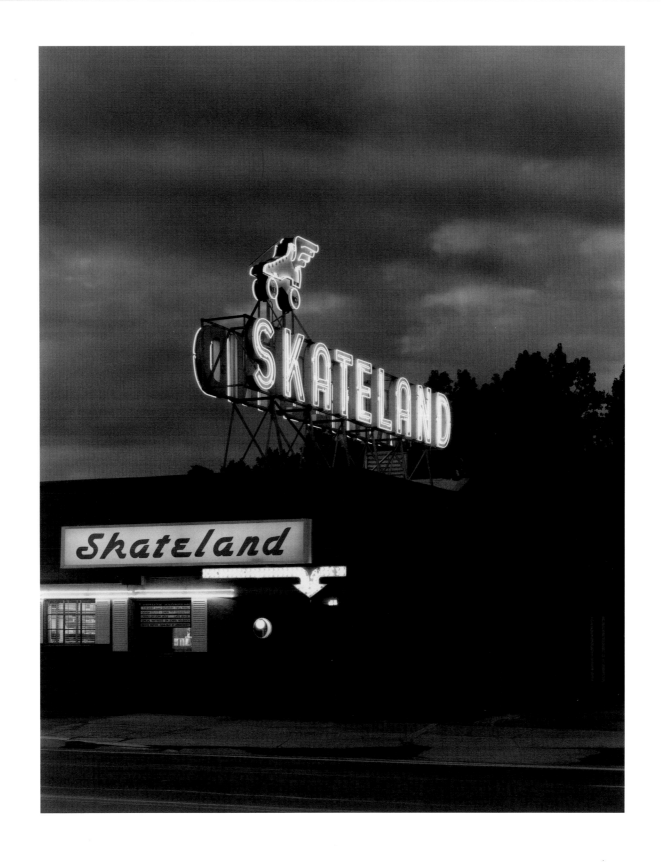

SKATELAND

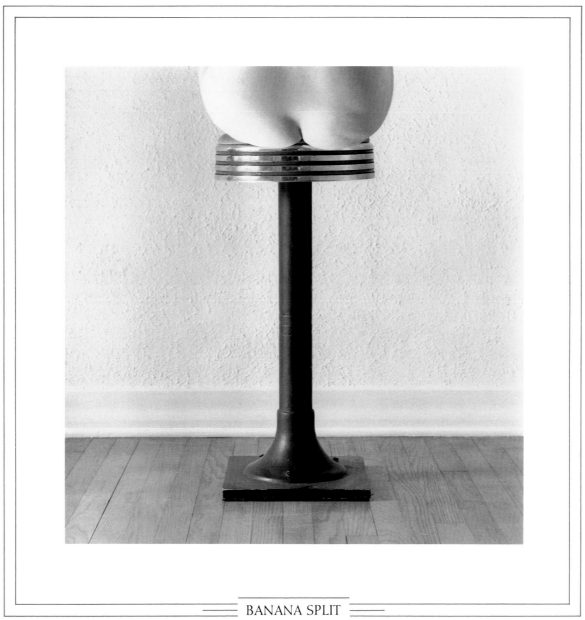

BANANA SPLIT

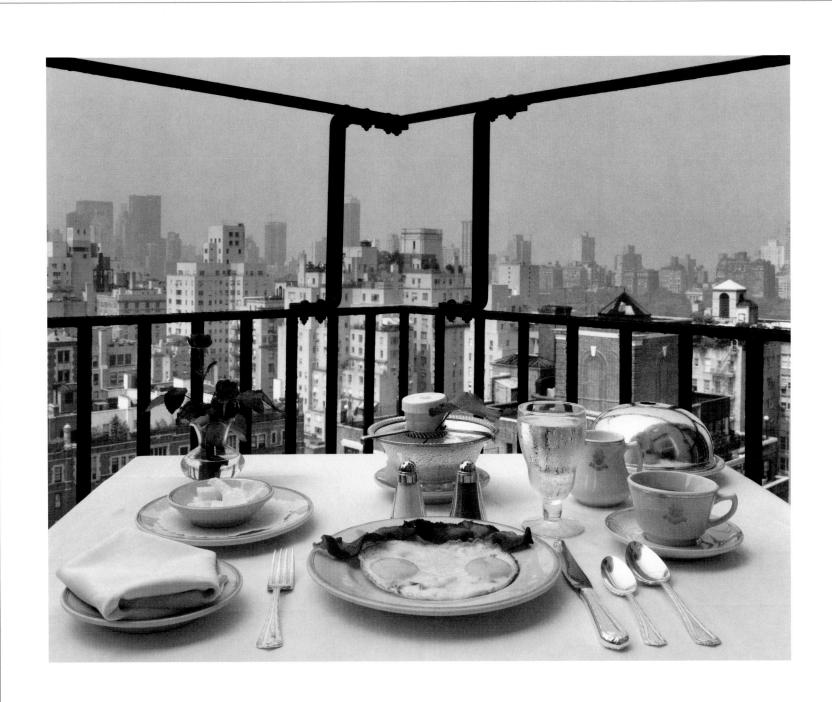

ROOM SERVICE

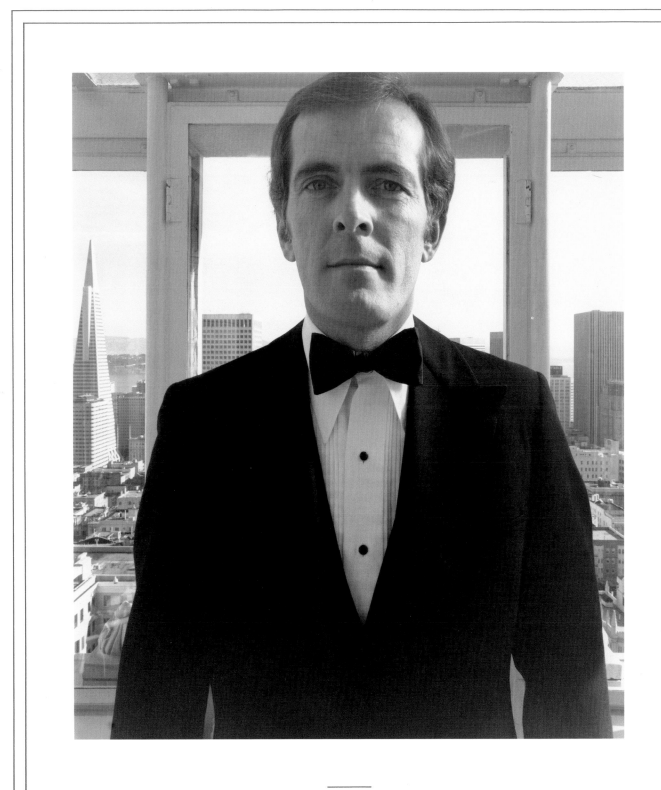

RON

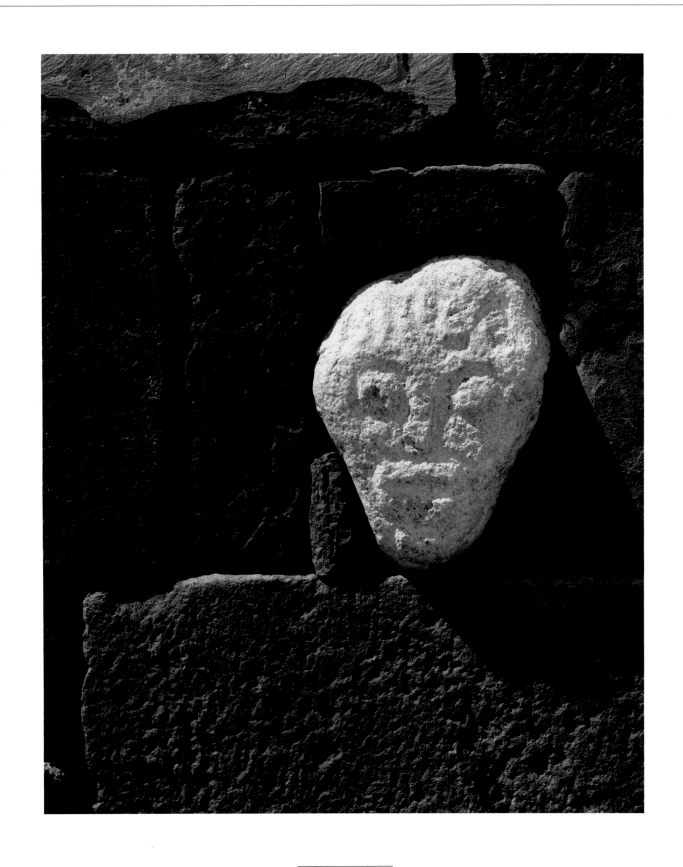

WHITE FACE

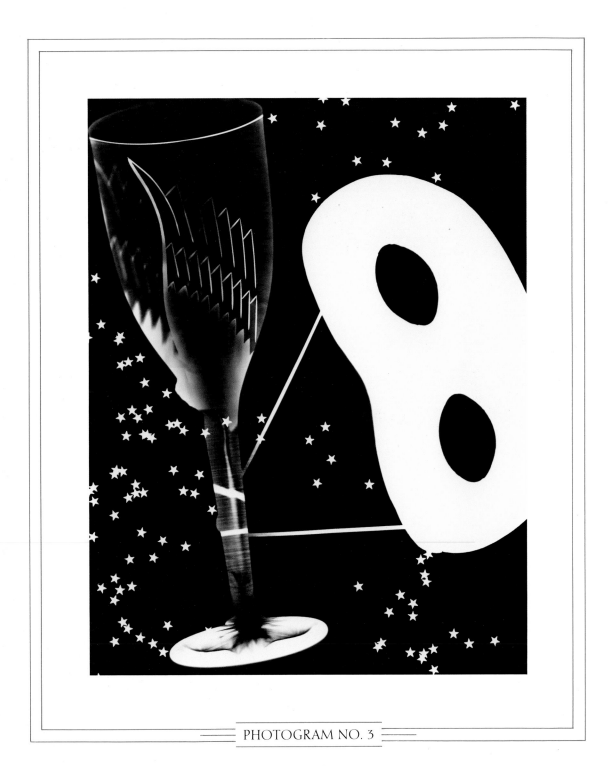

PHOTOGRAM NO. 3

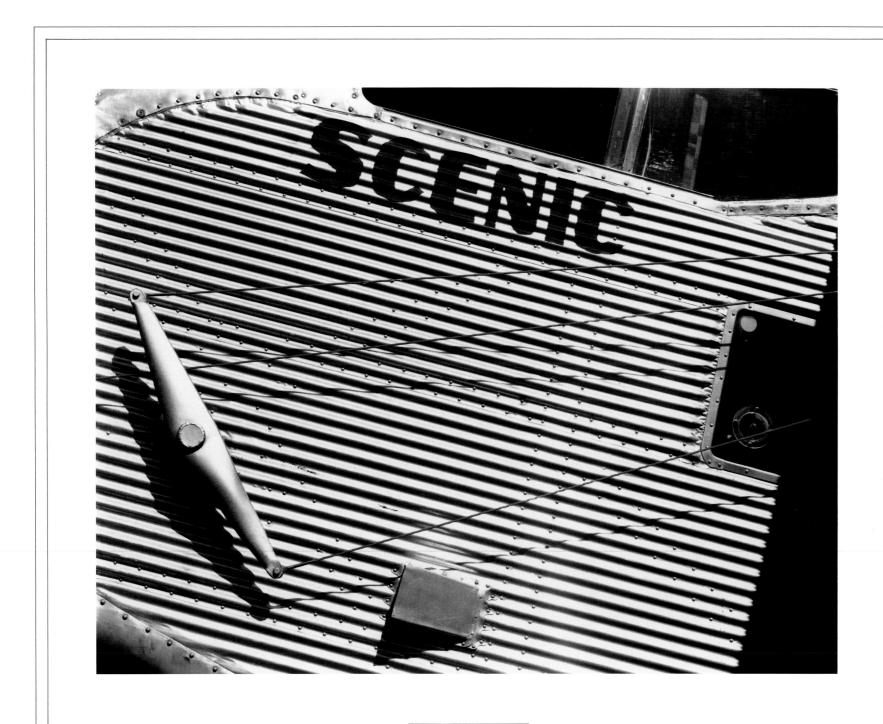

SCENIC AIRLINE

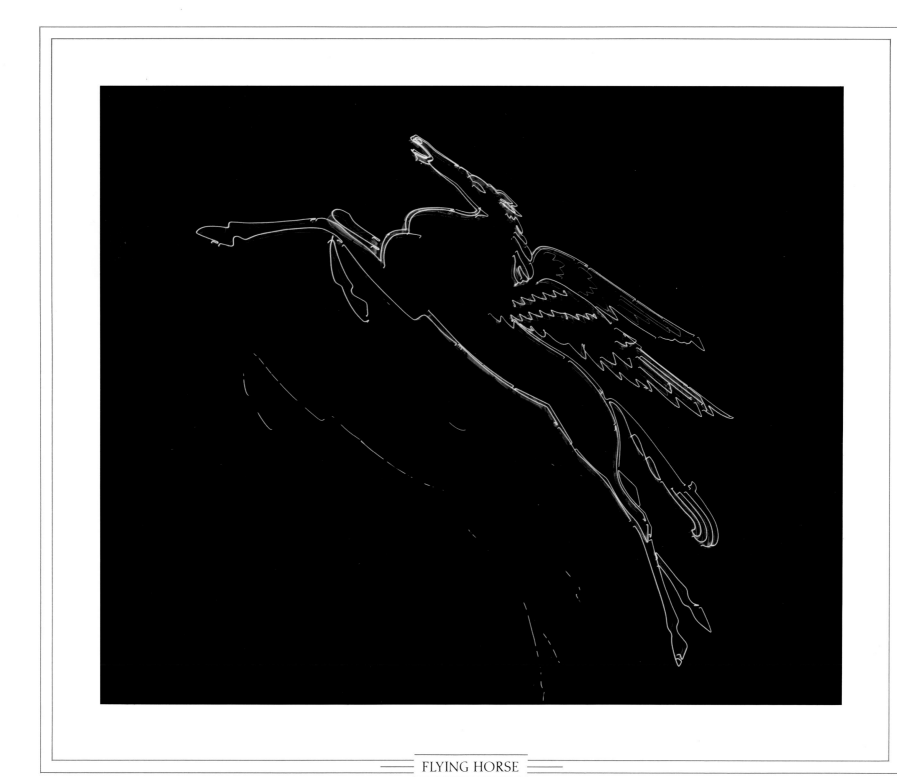

FLYING HORSE

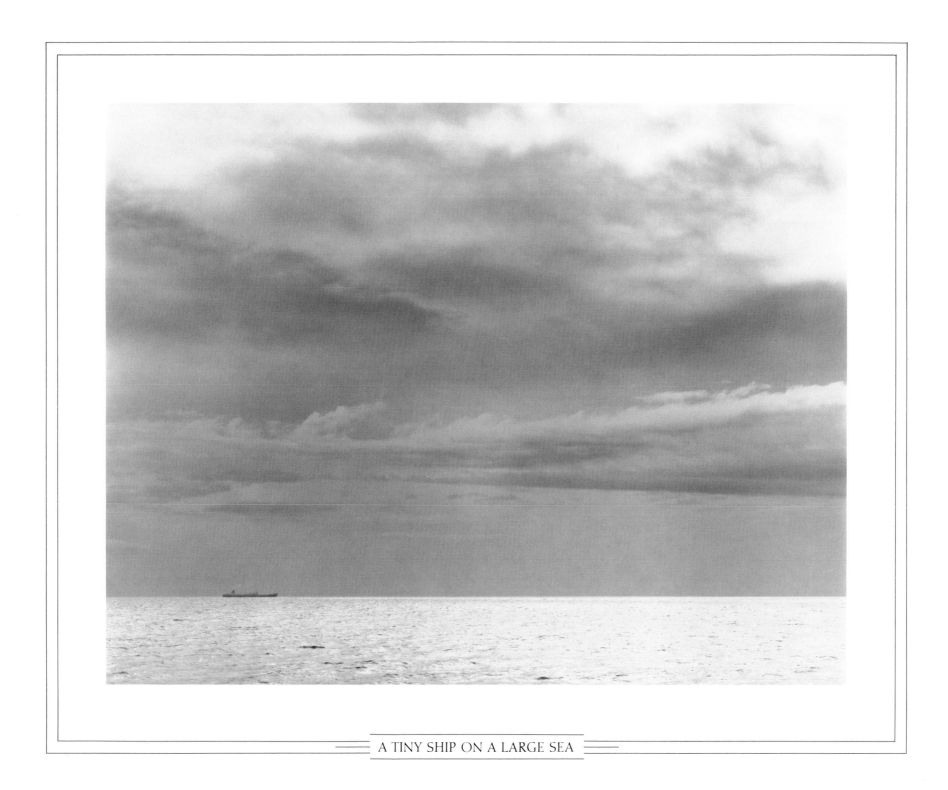

A TINY SHIP ON A LARGE SEA

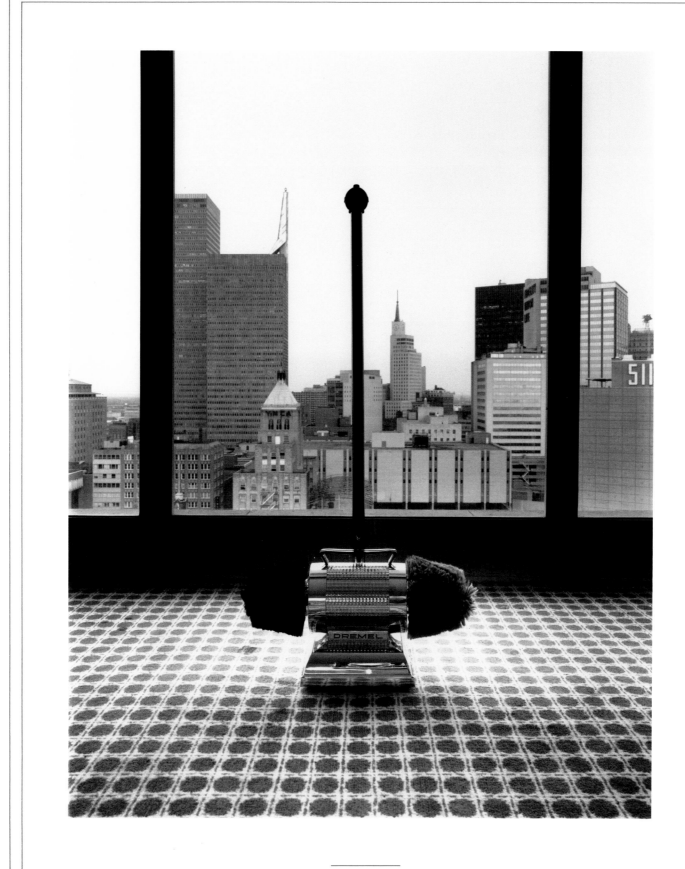

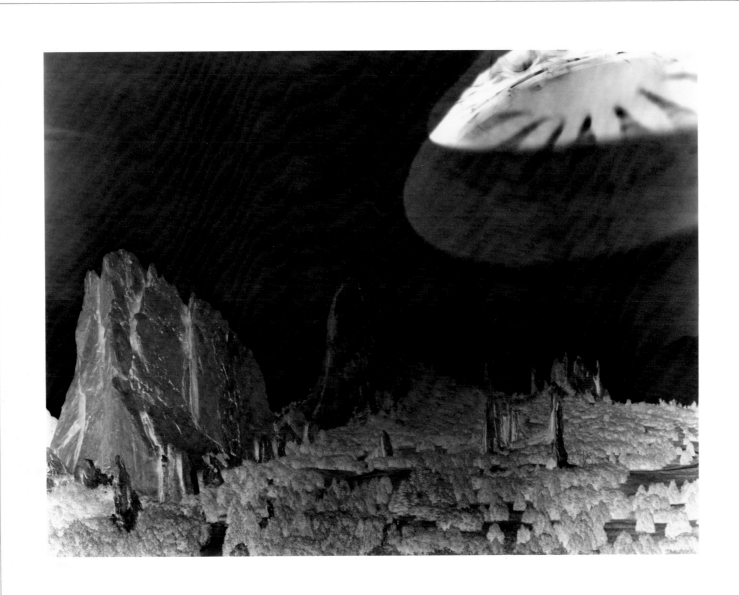

PHOTOGRAM NO. 7, GARDEN OF THE GODS

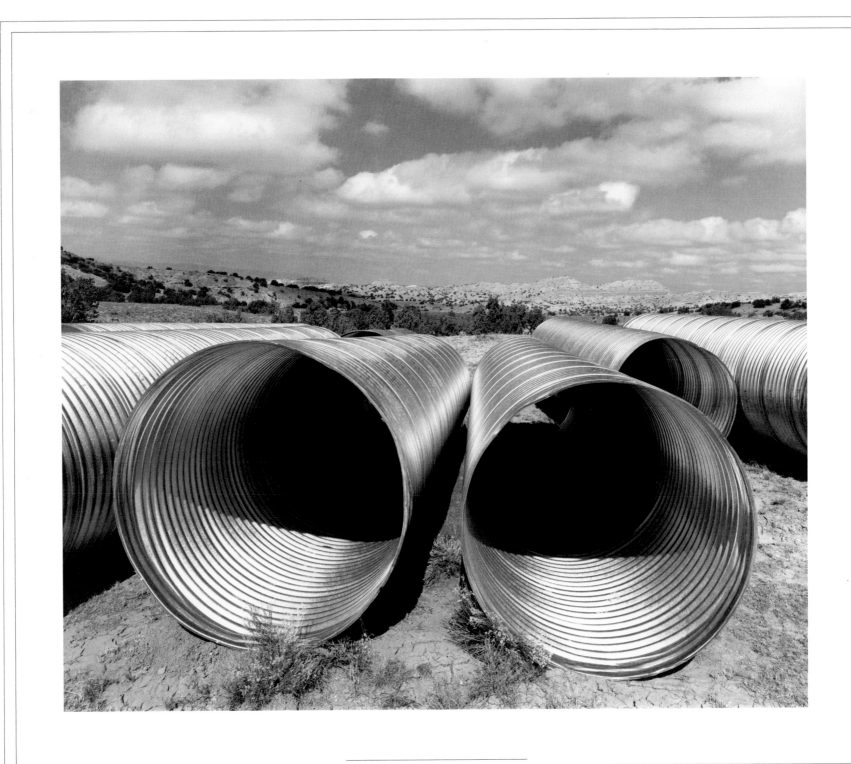

CULVERTS, NEW MEXICO

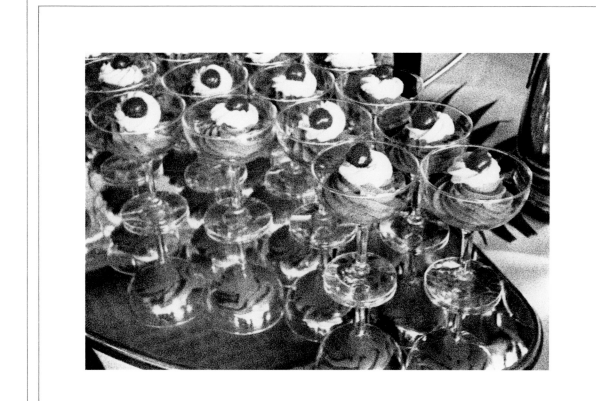

DESSERTS

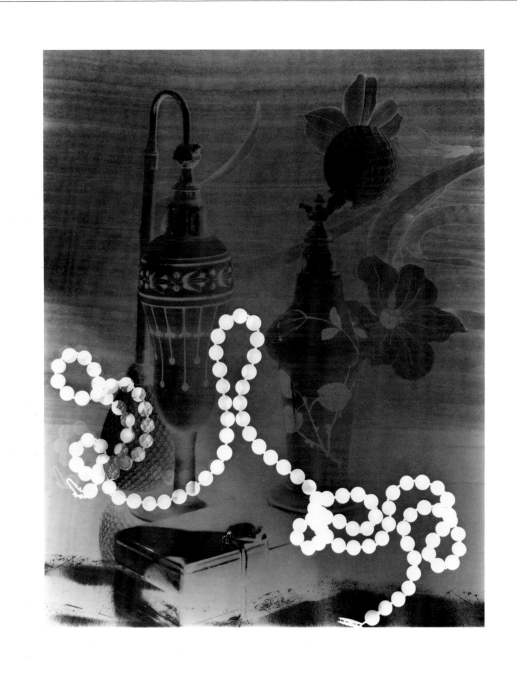

PHOTOGRAM NO. 2

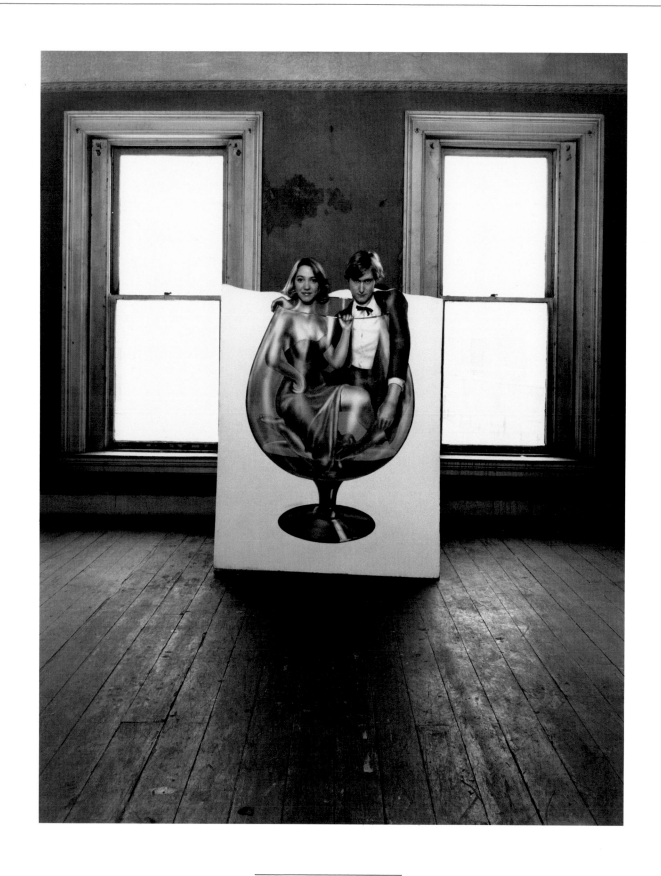

REHEARSAL DINNER

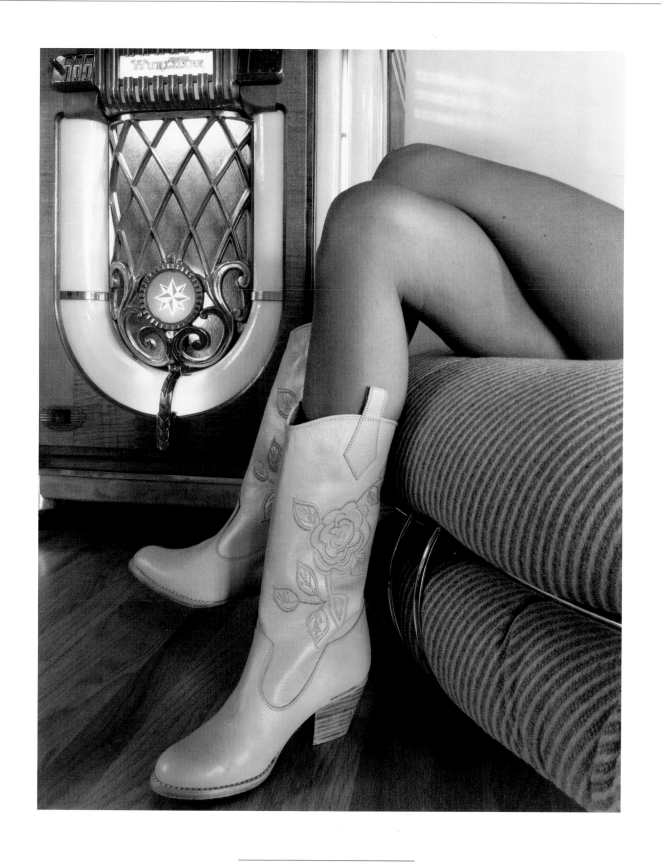

BOOTS AND WURLITZER

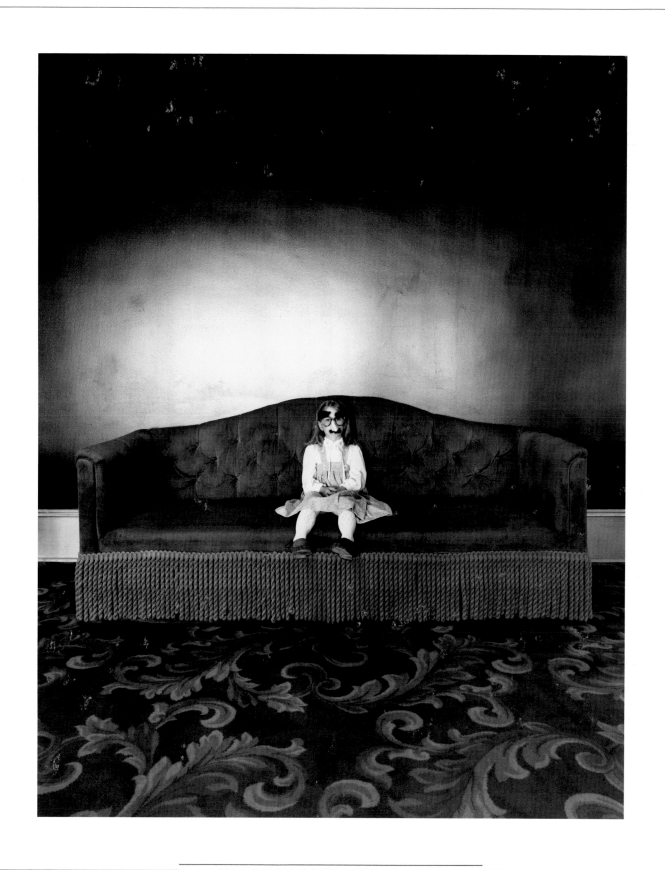

MELISSA IN THE LOBBY OF THE FAIRMONT

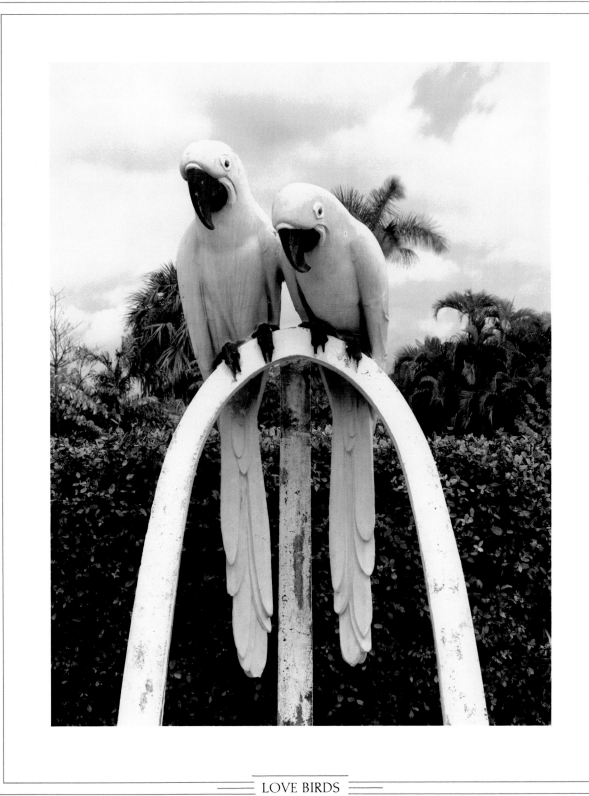

LOVE BIRDS

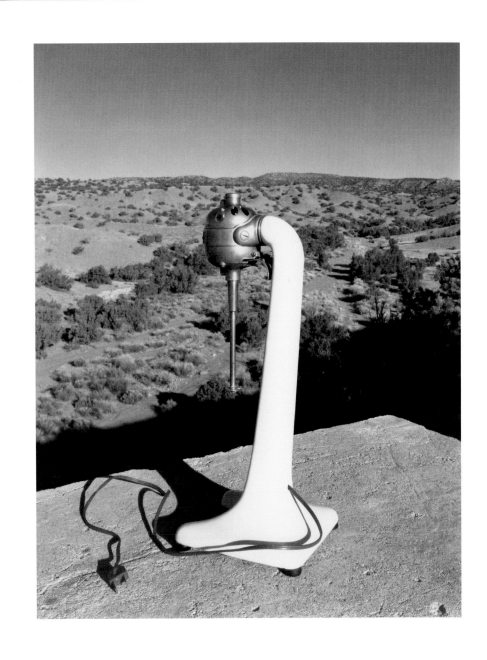

HAMILTON BEACH, NEW MEXICO

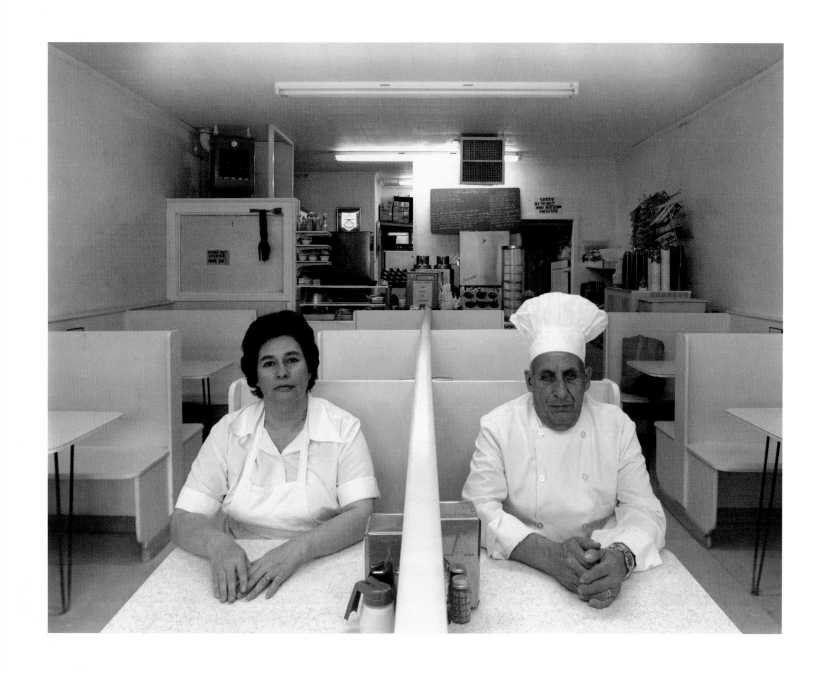

JOSIE'S

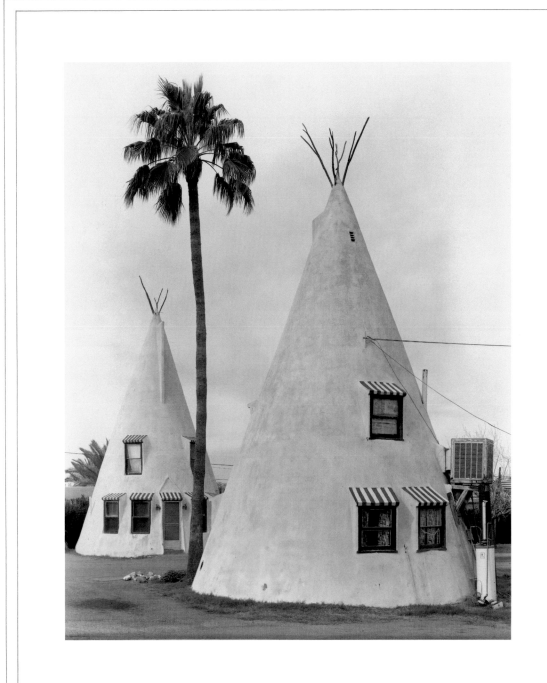

TEEPEES AND PALM TREES

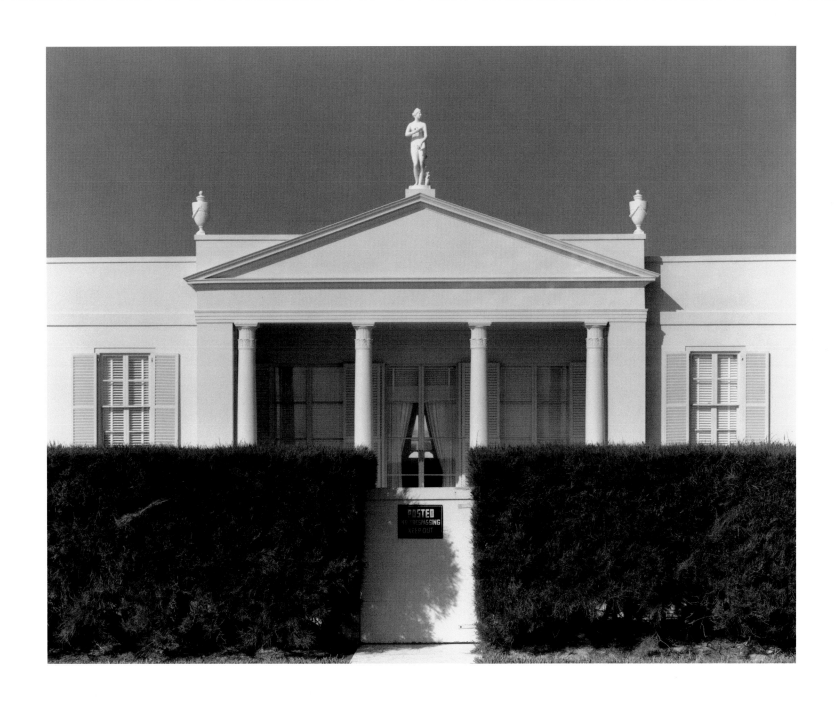

PALM BEACH

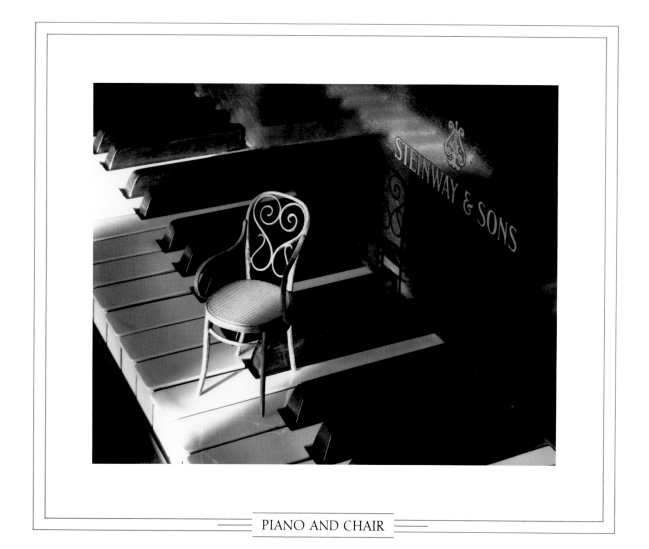

PIANO AND CHAIR

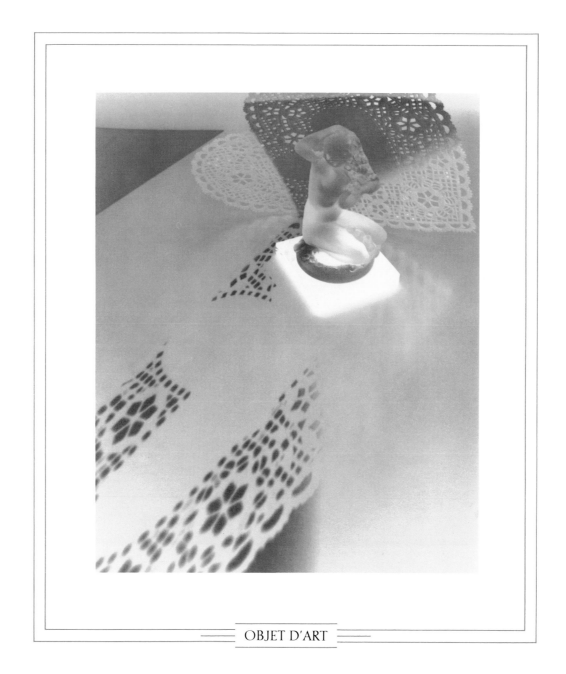

OBJET D'ART

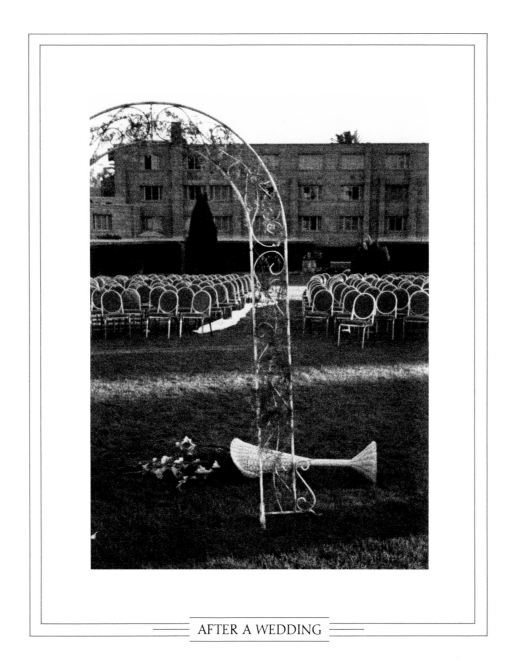

AFTER A WEDDING

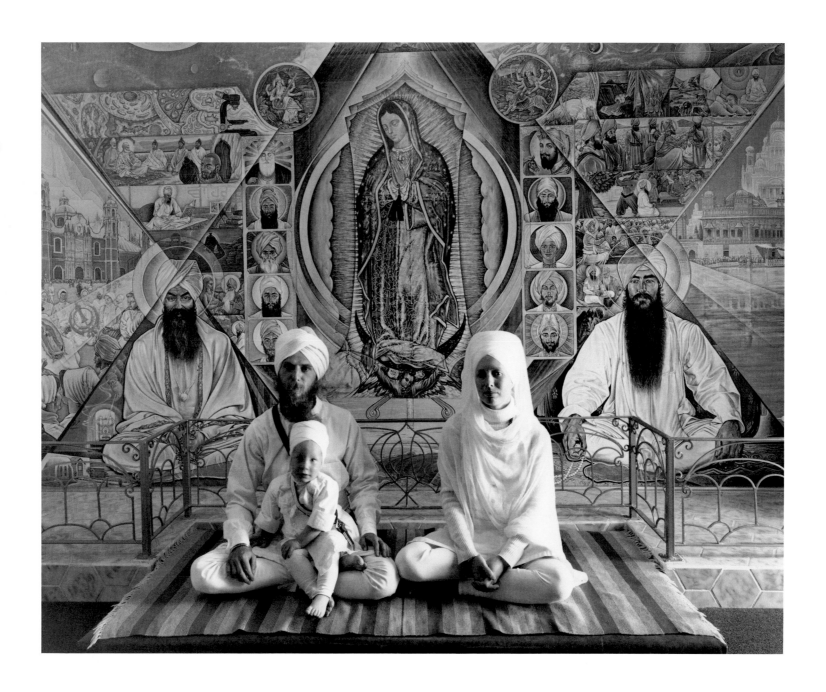

FAMILY PORTRAIT

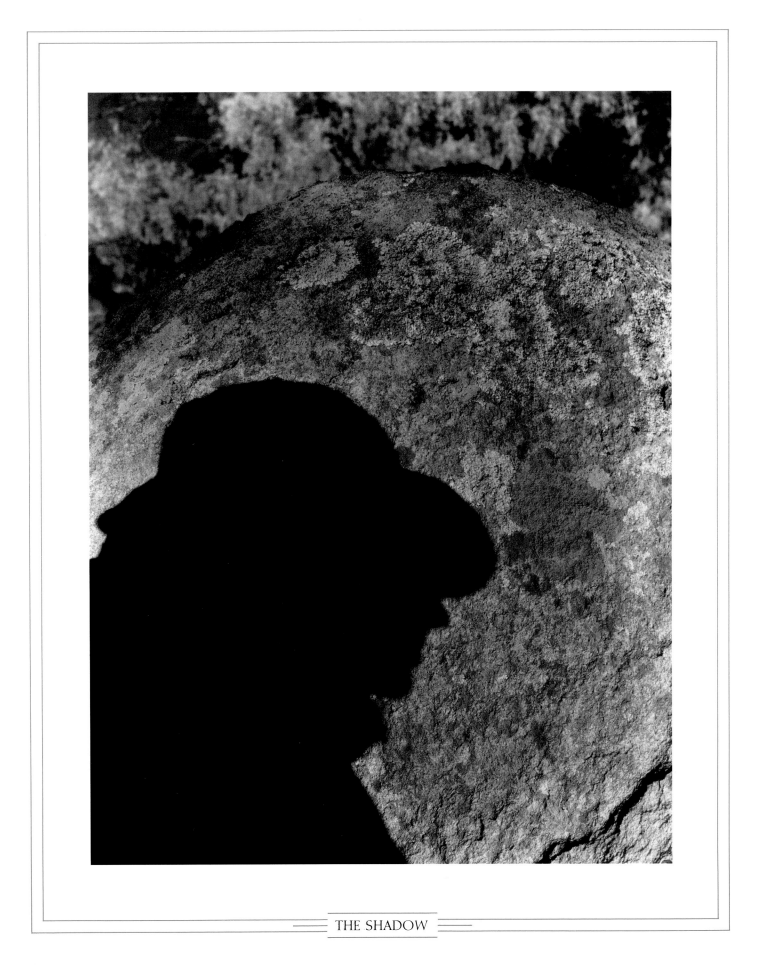

THE SHADOW

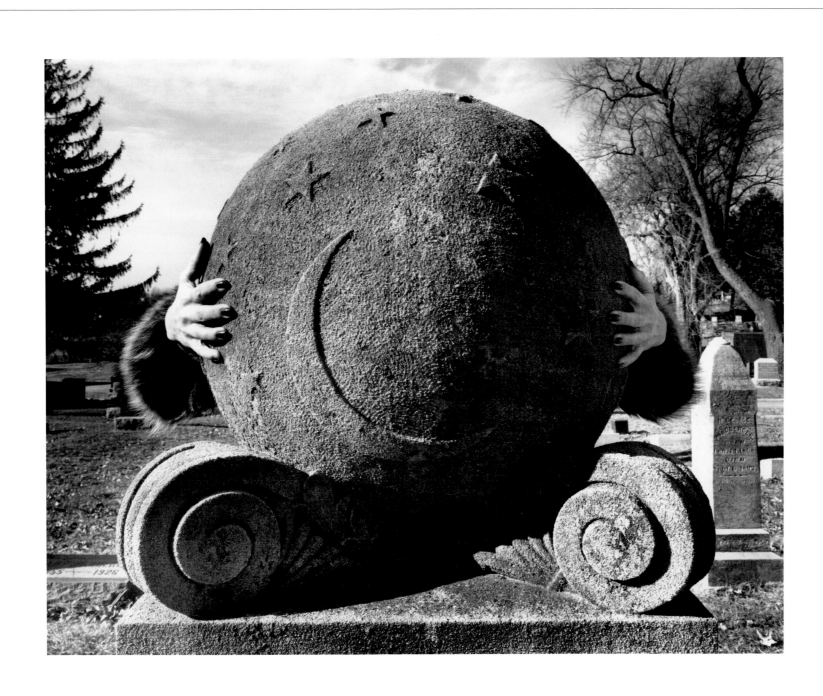

MT. MORA

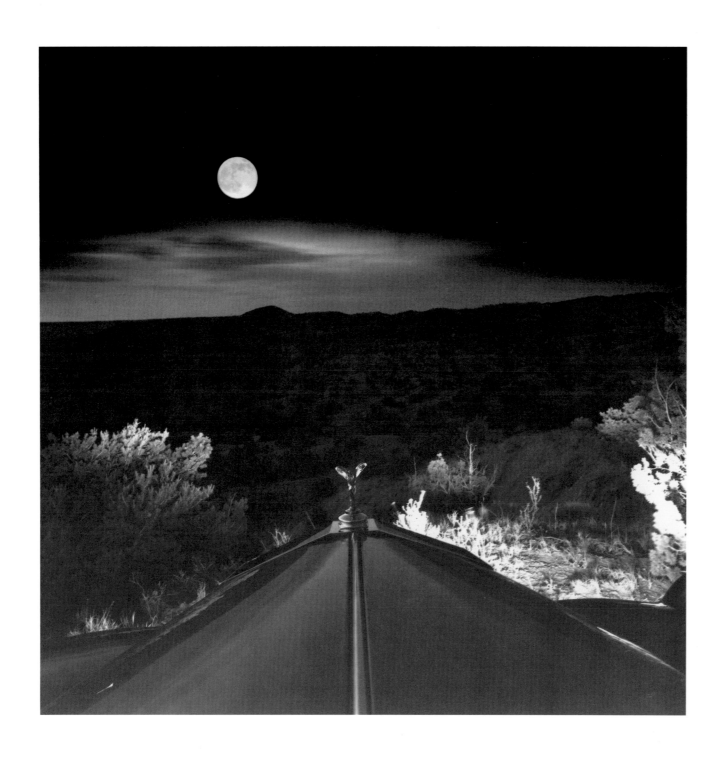

MOONRISE OVER ROLLS ROYCE

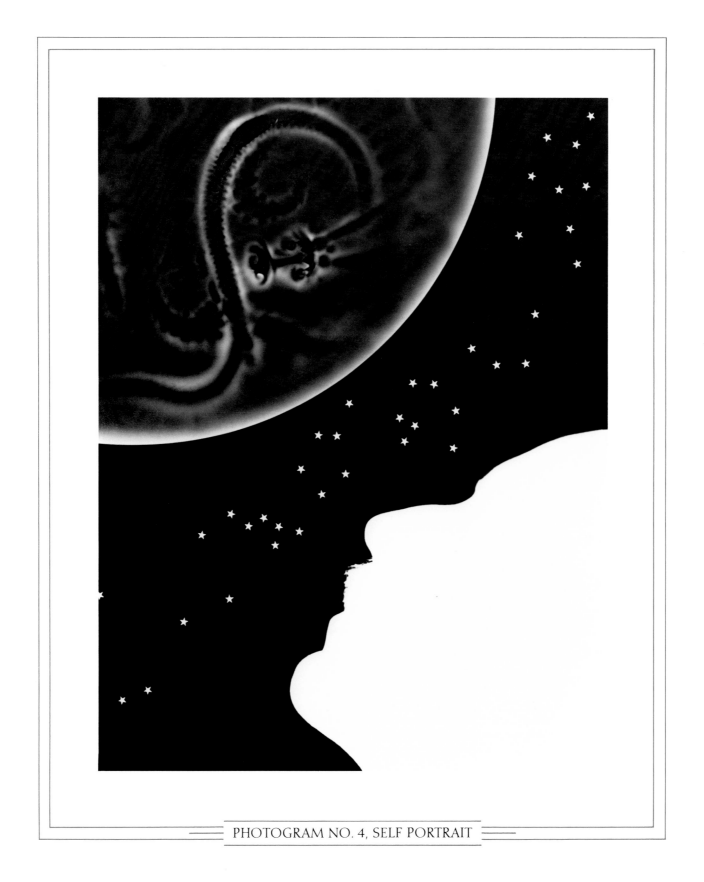

PHOTOGRAM NO. 4, SELF PORTRAIT

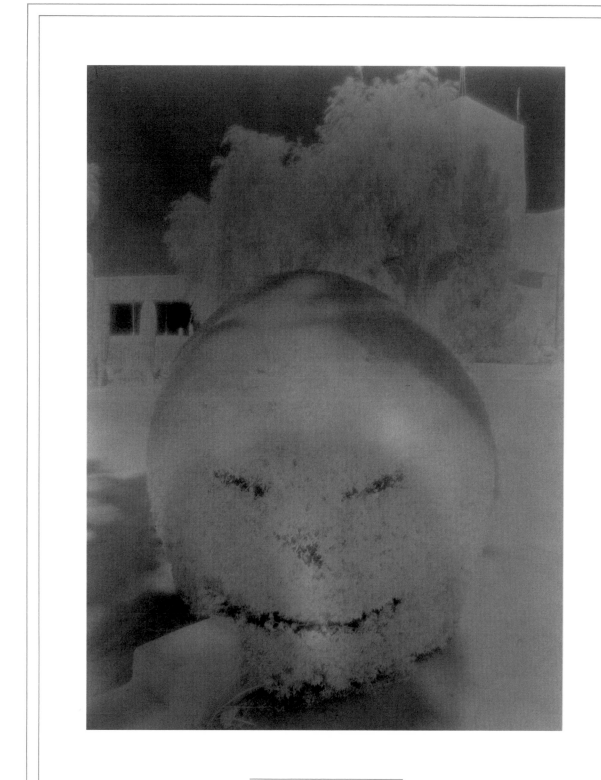

THE SMILING SHRUB

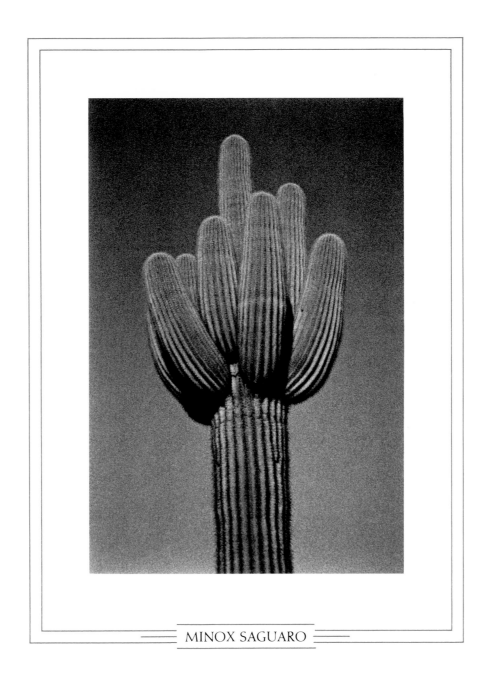

MINOX SAGUARO

Afterword

The purpose of this book is to entertain and communicate with the audience. My intention is to give the reader a pleasurable experience.

I am grateful to those professionals who have contributed creativity, knowledge, and expertise to enable this project to be completed. My sincere thanks to my family and friends who have supported my efforts over the years. Special love and appreciation to my wife Susan, who truly takes care of me and keeps me on the right path.

E.M.

People asking questions lost in confusion
Well I tell them there's no problem, only solutions
Well they shake their heads and look at me as if I've lost my mind
I tell them there's no hurry...
*I'm just sitting here doing time**

John Lennon

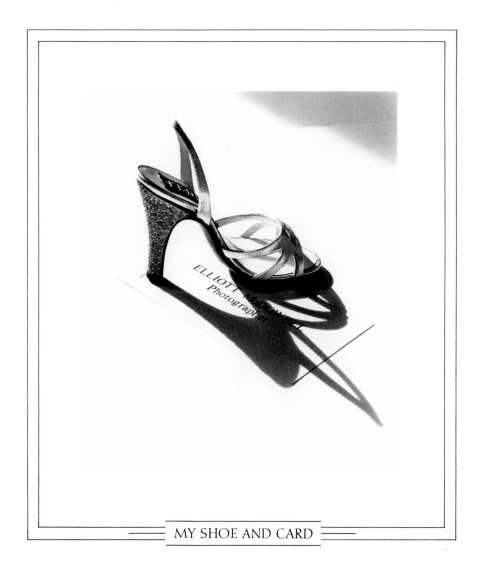

MY SHOE AND CARD